VINTAGE HAND FANS

COLORING BOOK

Marty Noble

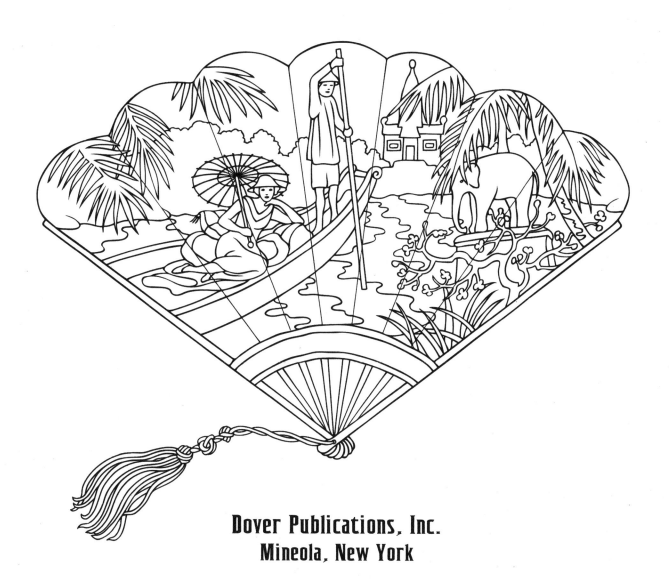

Dover Publications, Inc.
Mineola, New York

Hand fans have served many purposes throughout various times and cultures—from the obvious uses (creating a breeze, or hiding one's face) to the more exotic (theater programs, restaurant menus, and even advertisements). Although the use of fans can be traced as far back as ancient Egypt, their peak in popularity came with European women of the fifteen to eighteenth centuries, who used the hand fan as a status symbol representing wealth and class. These elaborately decorated and intricately detailed fashion accessories are an ideal addition to Dover's *Creative Haven* series for the experienced colorist. Many of the designs in this book are based on the fans in the collection of Anna Checcoli, a member of an ancient Italian noble family of French origin, who is known as a pre-eminent collector of fine antique fans.

Guide to the Vintage Hand Fans

1. Commemorative fan of one of the first balloon flights of Vincenzo Lunardi (1759–1806). English or Italian. Collection of Anna Checcoli.

2. French folding fan. Signed by M. Moreau, 1890. Collection of Anna Checcoli.

3. Chinese fan. Nineteenth century.

4. **Top.** French folding fan. Signed by Jubien Mika. Collection of Anna Checcoli. **Bottom.** French advertising fan for Cordon Rouge, a champagne maker, 1925. G. H. Mumm & Co.

5. American or European, 1860s. Metropolitan Museum of Art.

6. Spanish, eighteenth century. Metropolitan Museum of Art.

7. Brisé fan. France, 1830s. Collection of David J. Ranftl.

8. Two fans made from original lithographs by Privat Livemont. France, 1899. Collection of Anna Checcoli.

9. Rare Flemish folding fan, 1770. Collection of Anna Checcoli.

10. French, 1903. Metropolitan Museum of Art.

11. Folding Fan. Signed by Gabrielle Zaborowska, a painter for Duvelleroy and other famous houses of design. Paris, 1889. Collection of Anna Checcoli.

12. Mandarin, early nineteenth century.

13. Italian folding fan, 1910. Collection of Anna Checcoli.

14. English hand fan, 1760–70. Victoria & Albert Museum.

15. French advertising palmettes fan for the store "Au Bon Marche." Printed by E. Barret in Paris, 1900. Collection of Anna Checcoli.

16. Italian folding fan, 1700.

17. Chinese asymmetrical fan. Nineteenth century.

18. Advertising hand fans, 1920s.

19. French, 1830–40. Probably made for the Spanish market. Victoria & Albert Museum.

20. Japanese folding fan, 1889. Collection of Anna Checcoli.

21. Japanese man's fan depicting falconry, early Meiji or Edo period.

22. Art Nouveau advertising fan for Putman Dyes, 1920s.

23. Chinese export fan, 1830.

24. French folding fan, 1800–1809. Metropolitan Museum of Art.

25. French fan. Produced and signed by Ernest Kees, 1895/1900. Collection of Anna Checcoli.

26. Fan crafted from bleached water buffalo hide and horn, late 1800s.

27. French folding fan made by Duvelleroy and commemorative of Lyons Universal exhibition, 1914.

28. Antique European carved bone folding fan, late 1800s.

29. Antique uchiwa (Japanese fan) with geisha.

30. European, early nineteenth century. Metropolitan Museum of Art.

31. Mandarin export fan, 1789.

Bibliographical Note

Vintage Hand Fans Coloring Book is a new work, first published by Dover Publications, Inc., in 2014.

International Standard Book Number

ISBN-13: 978-0-486-78062-7
ISBN-10: 0-486-78062-7

Manufactured in the United States by RR Donnelley
78062707 2015
www.doverpublications.com

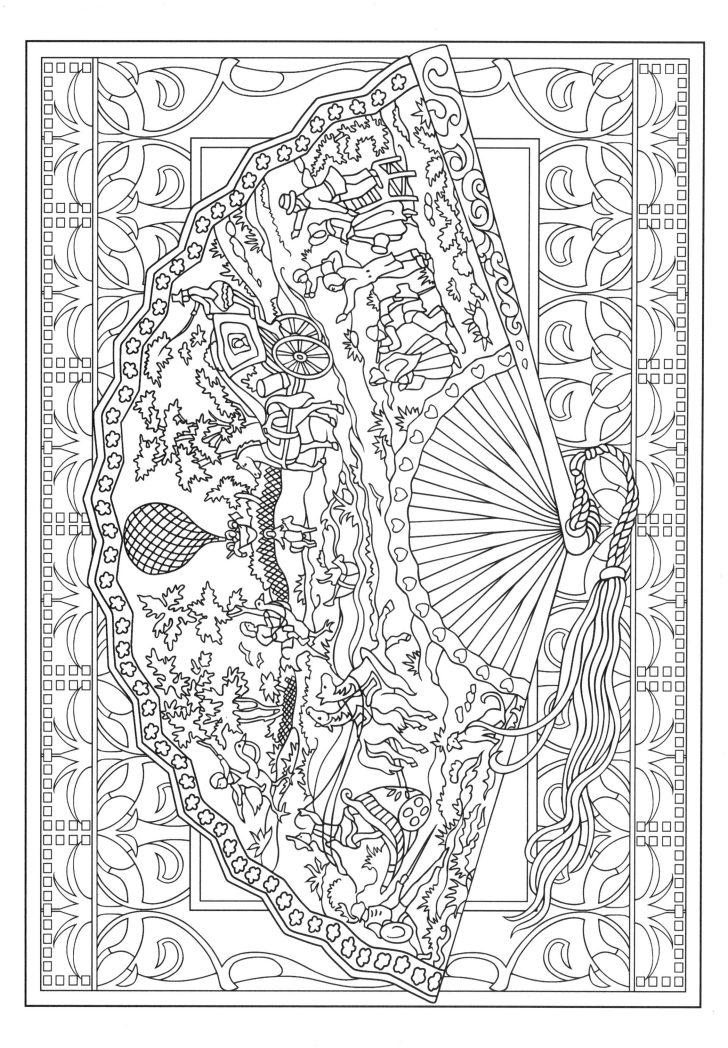

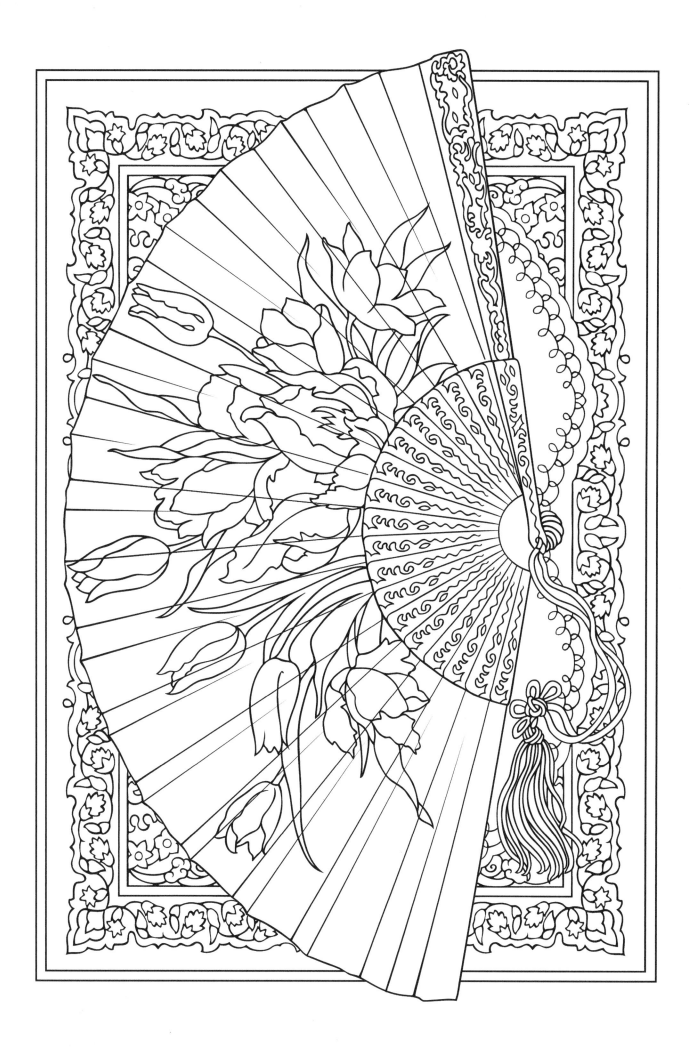

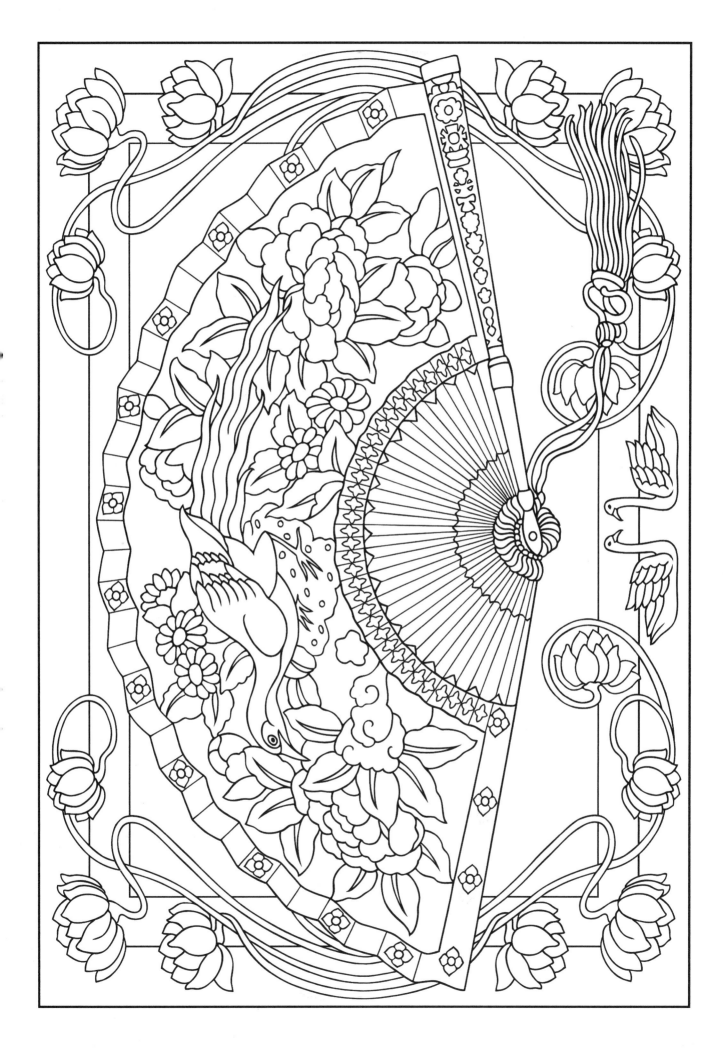

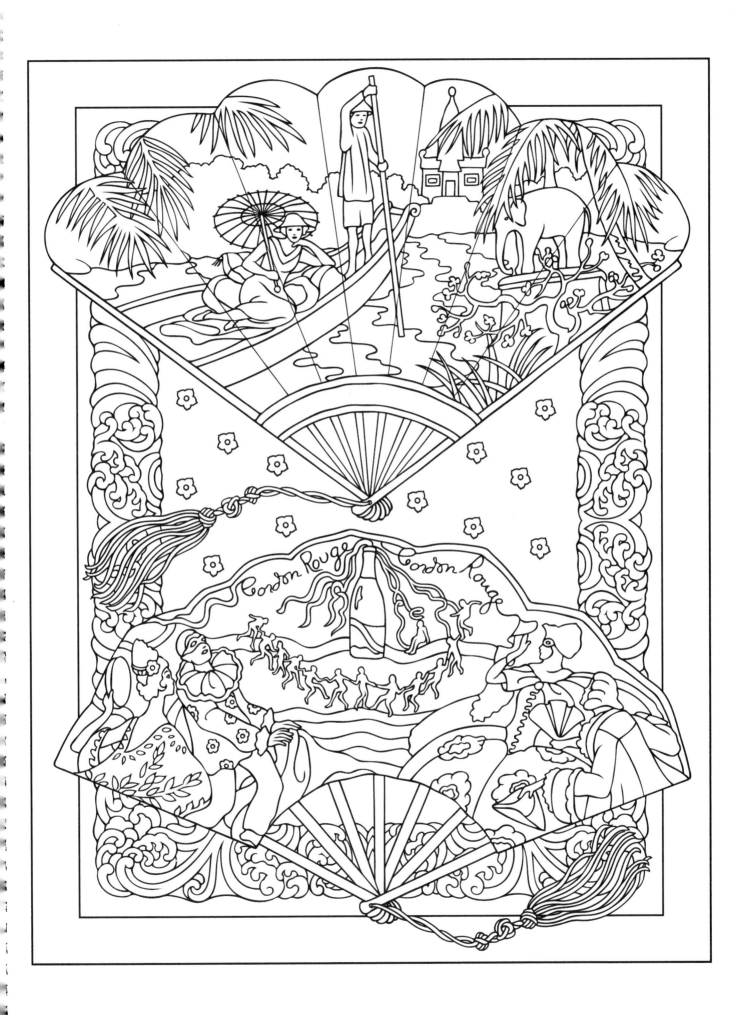

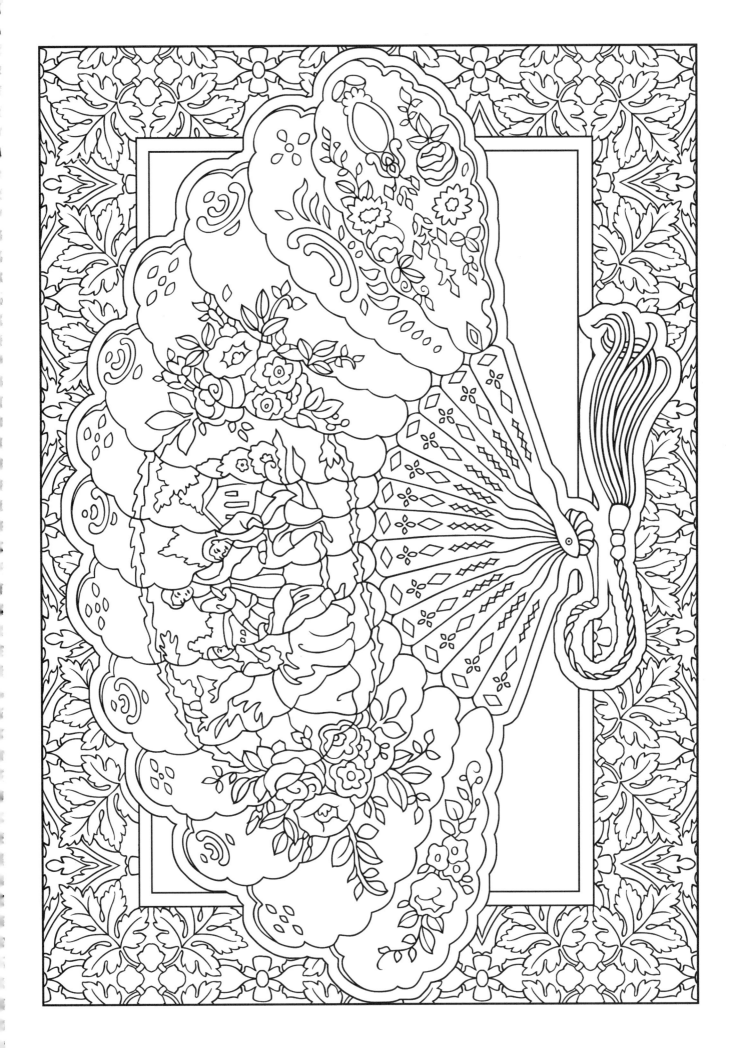

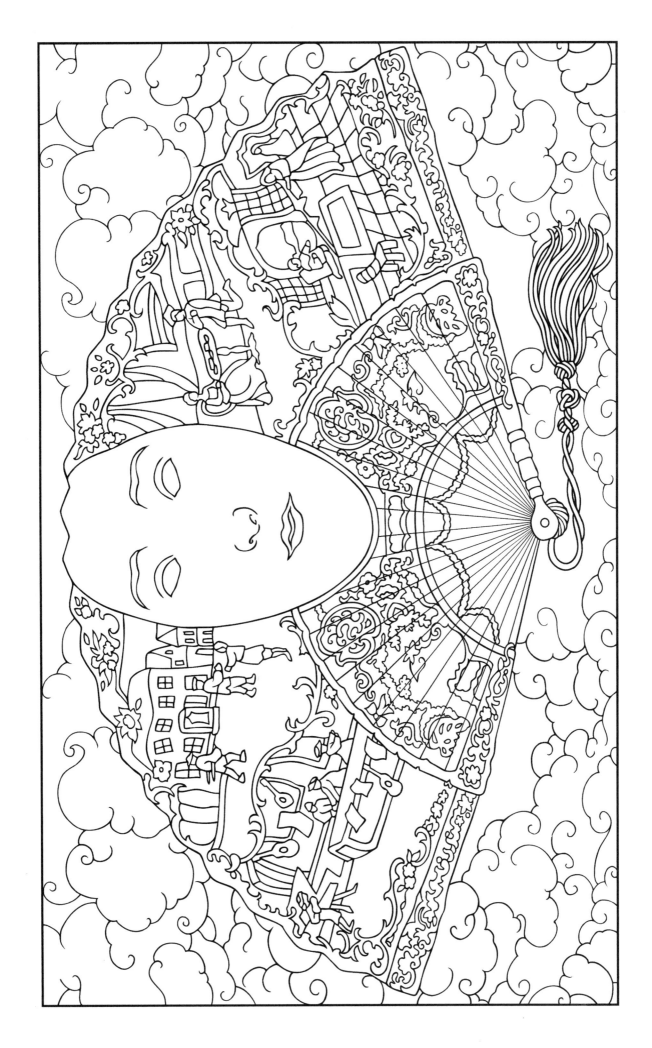

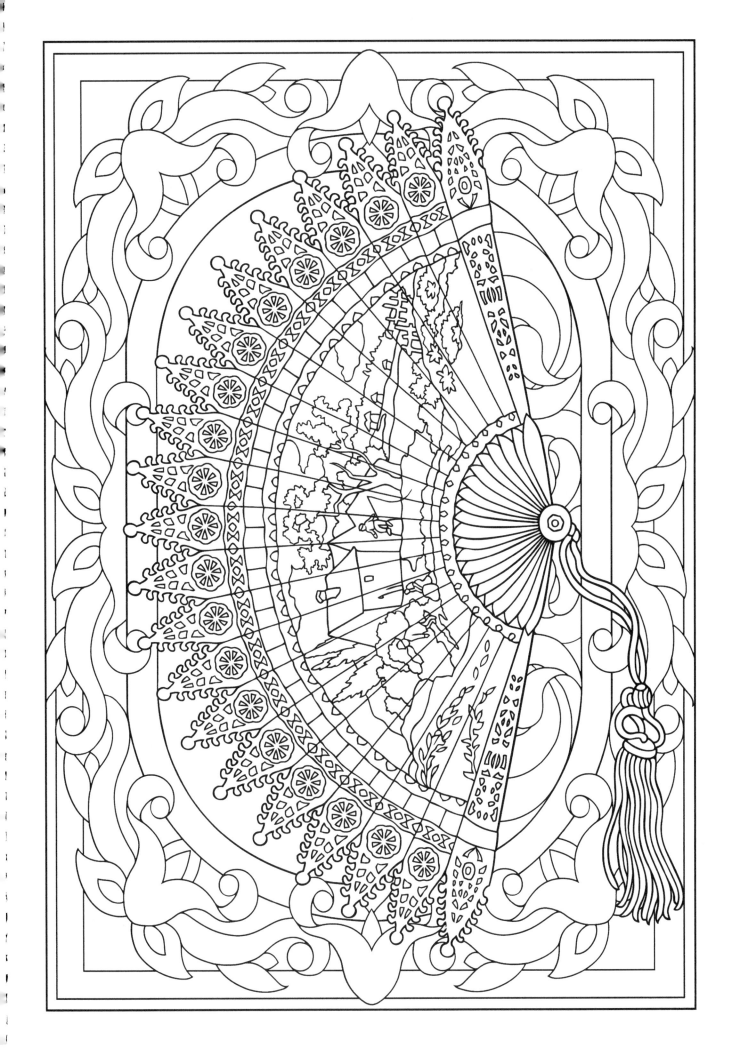

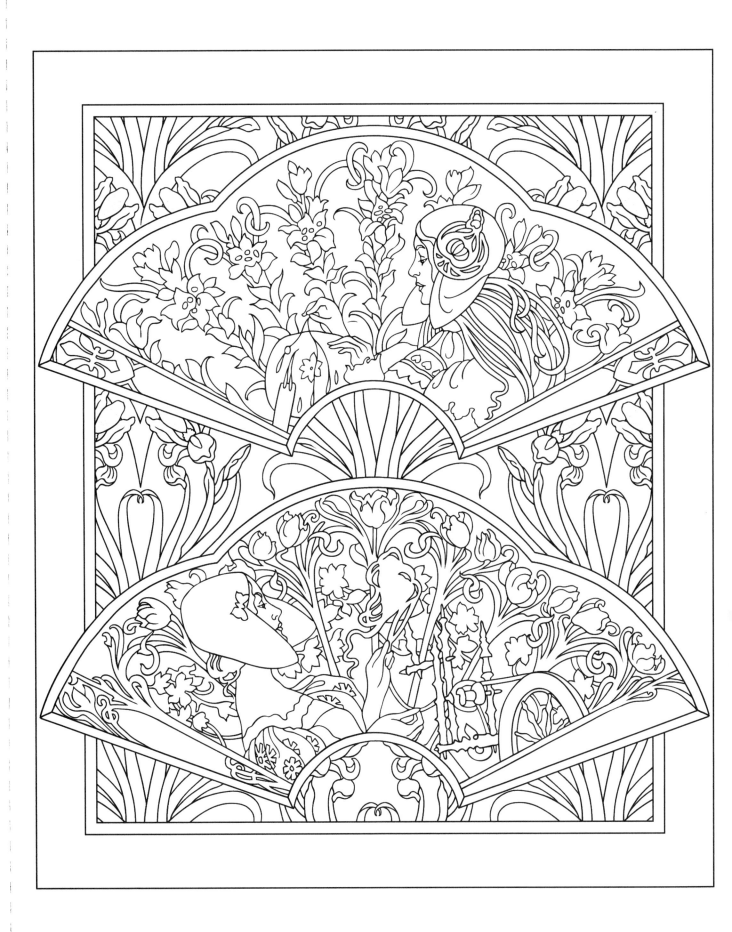

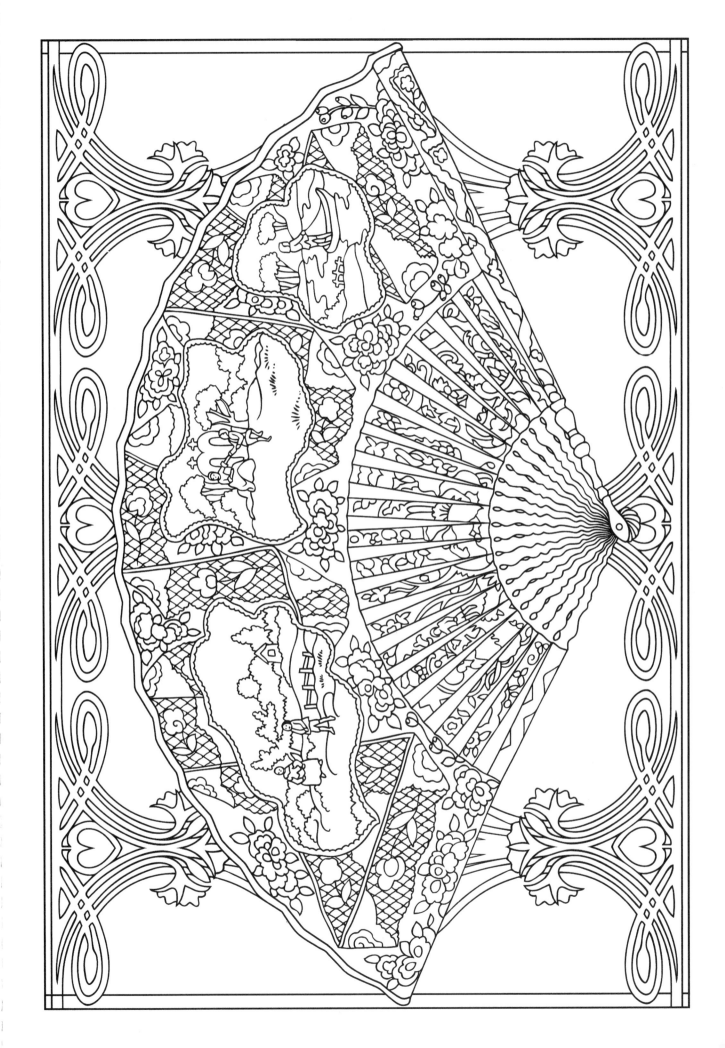

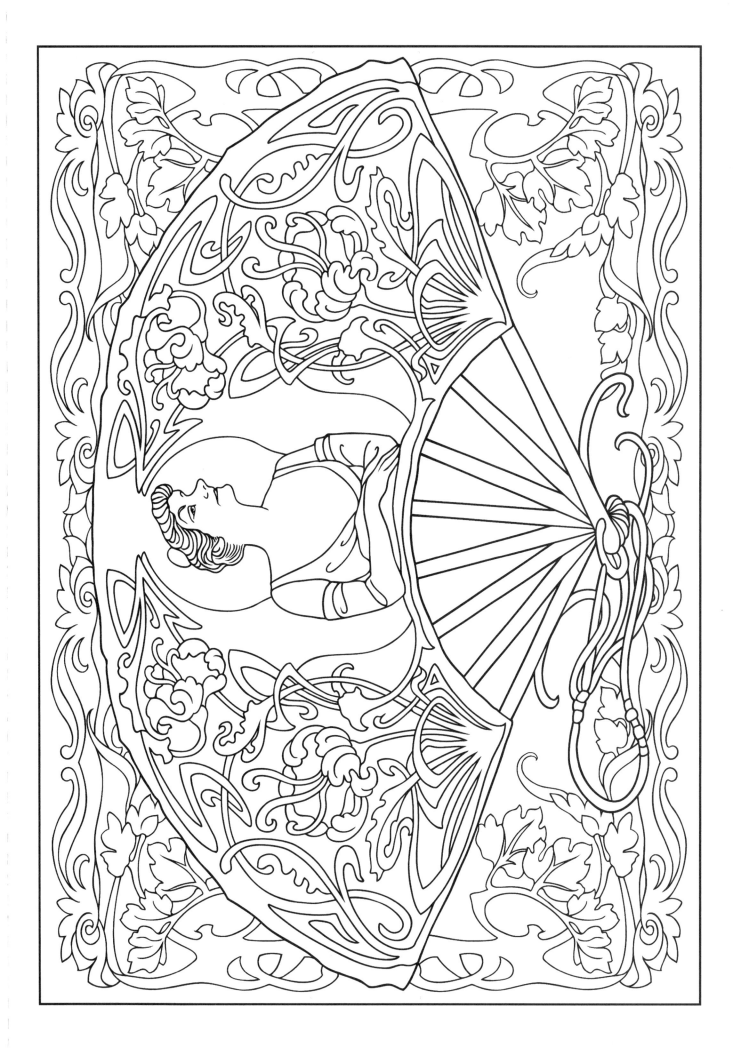

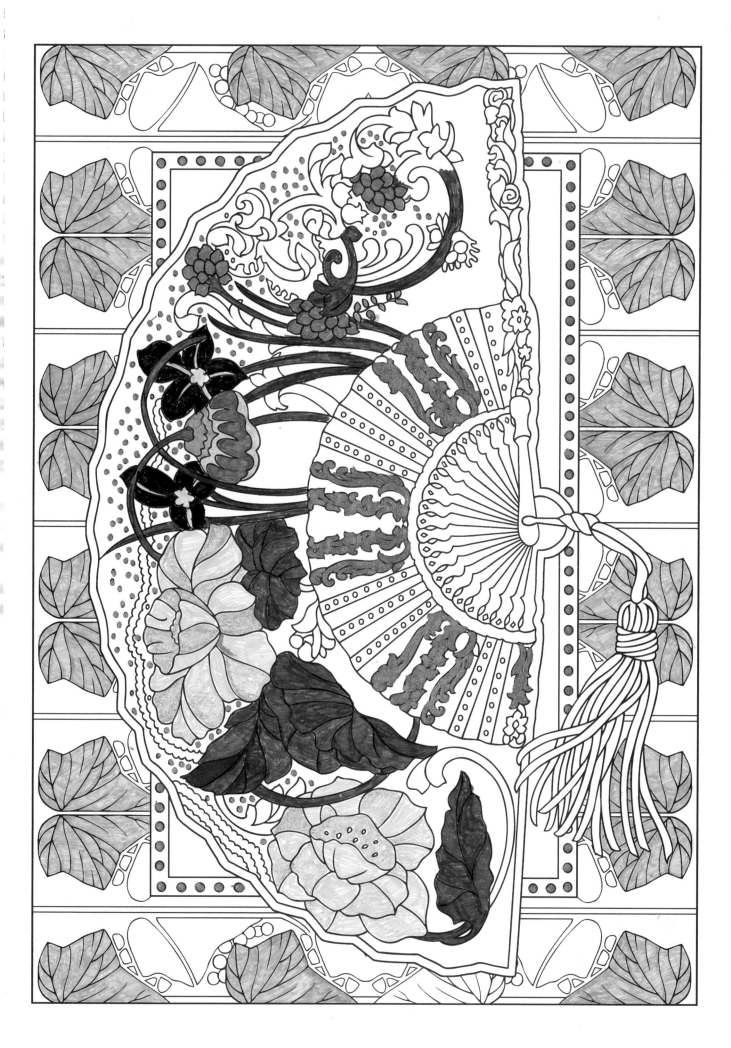

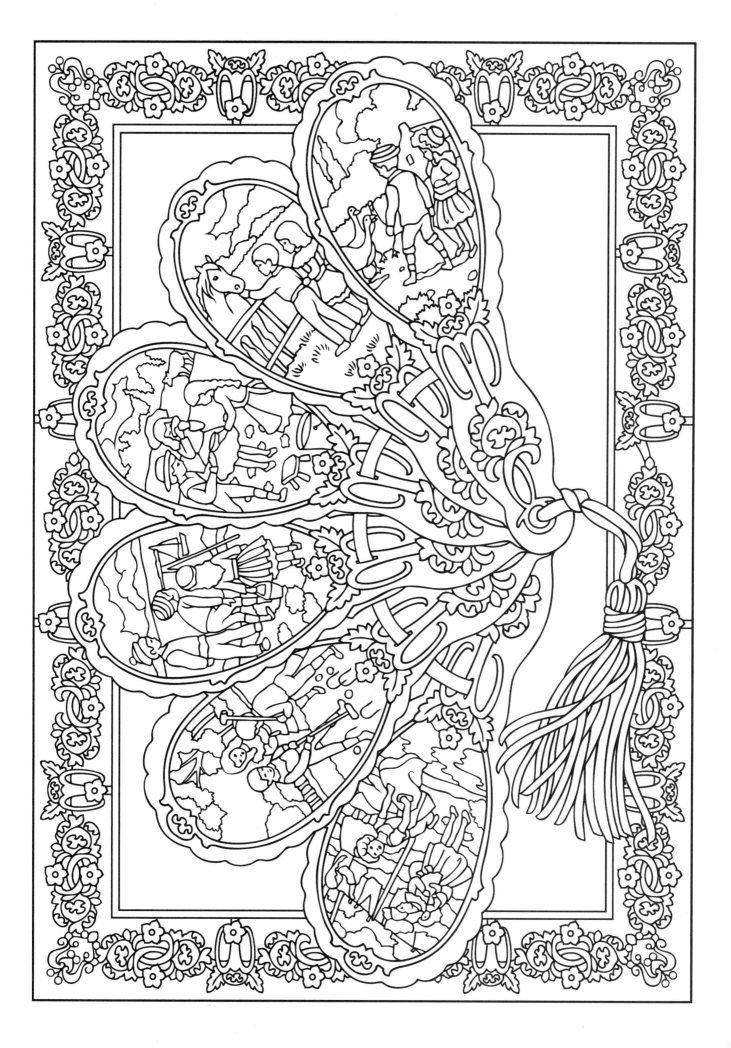

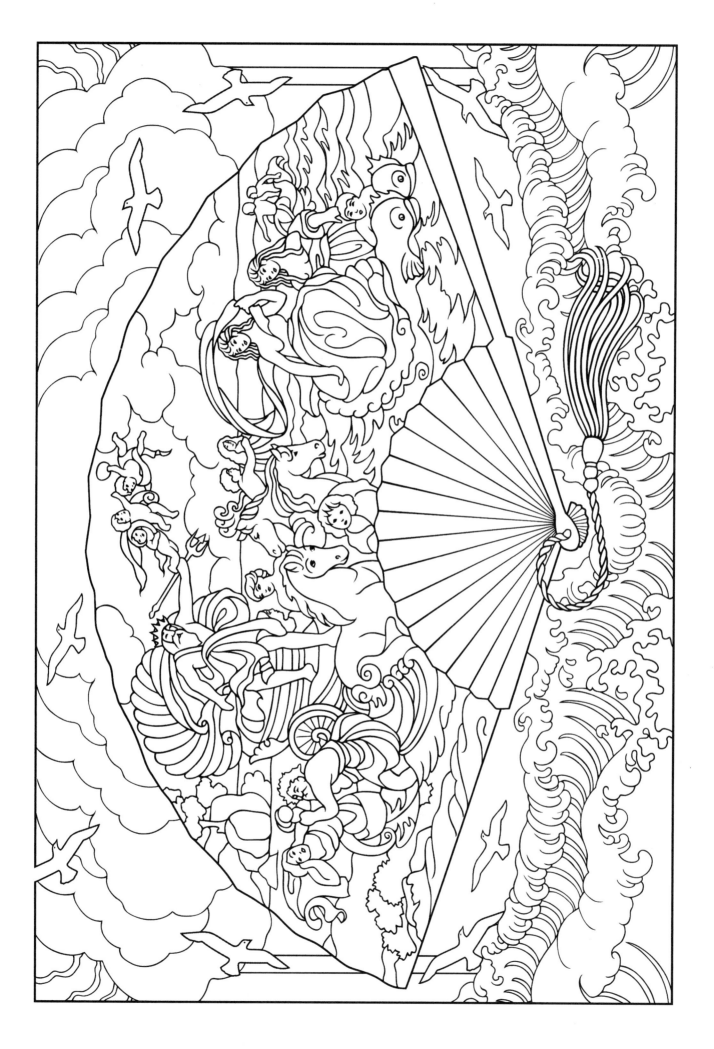

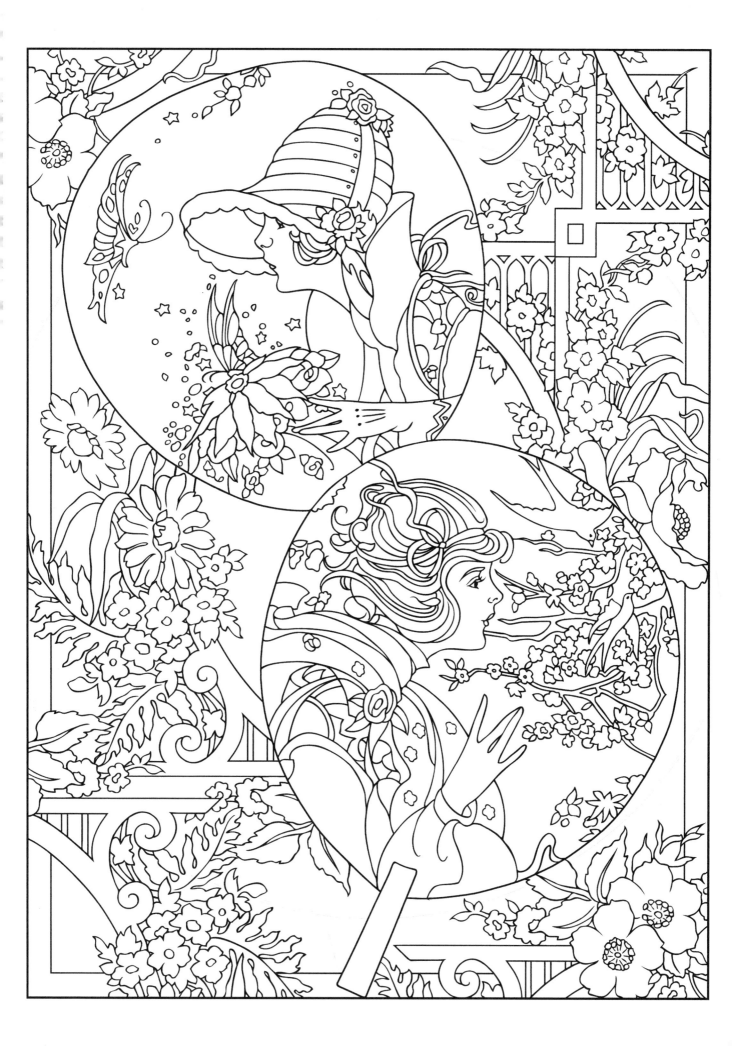

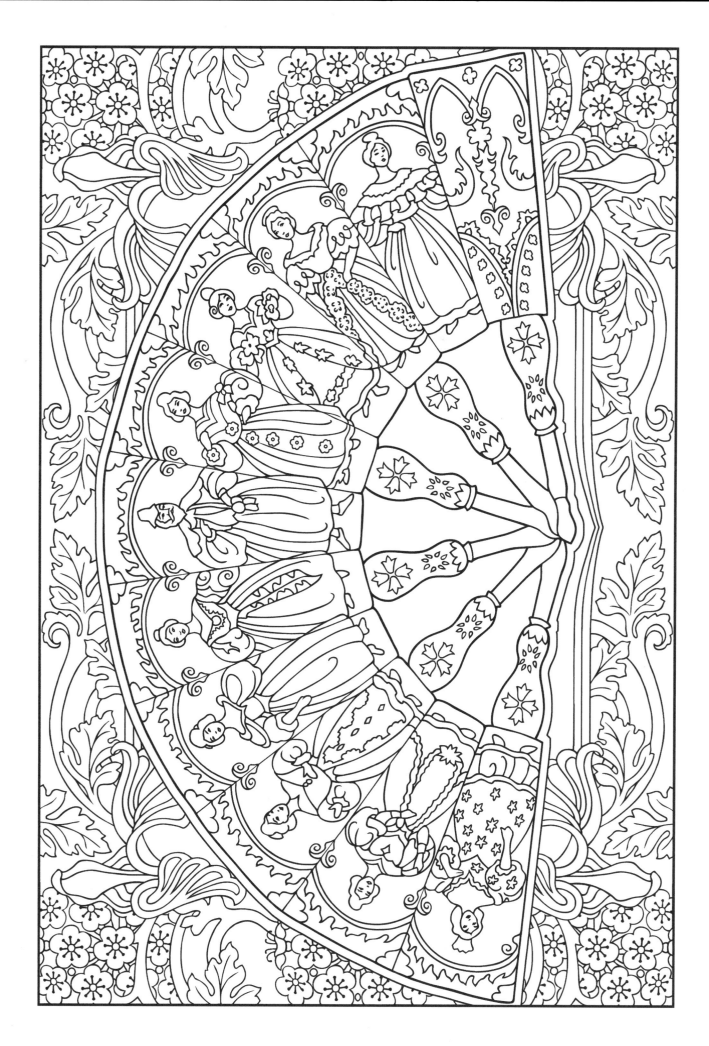

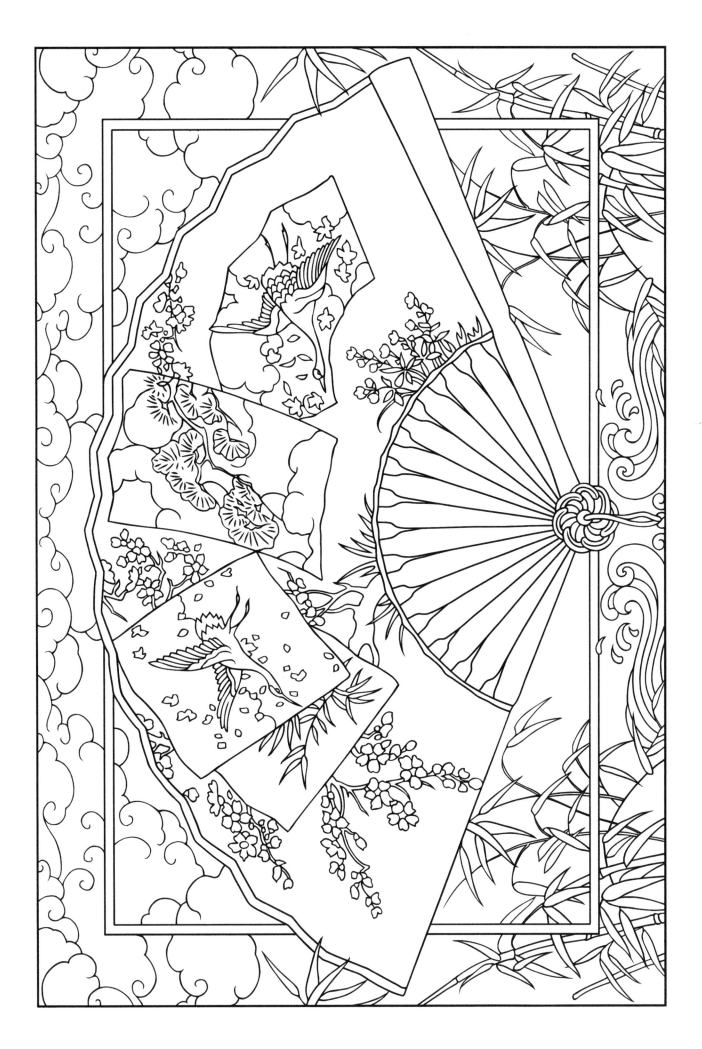

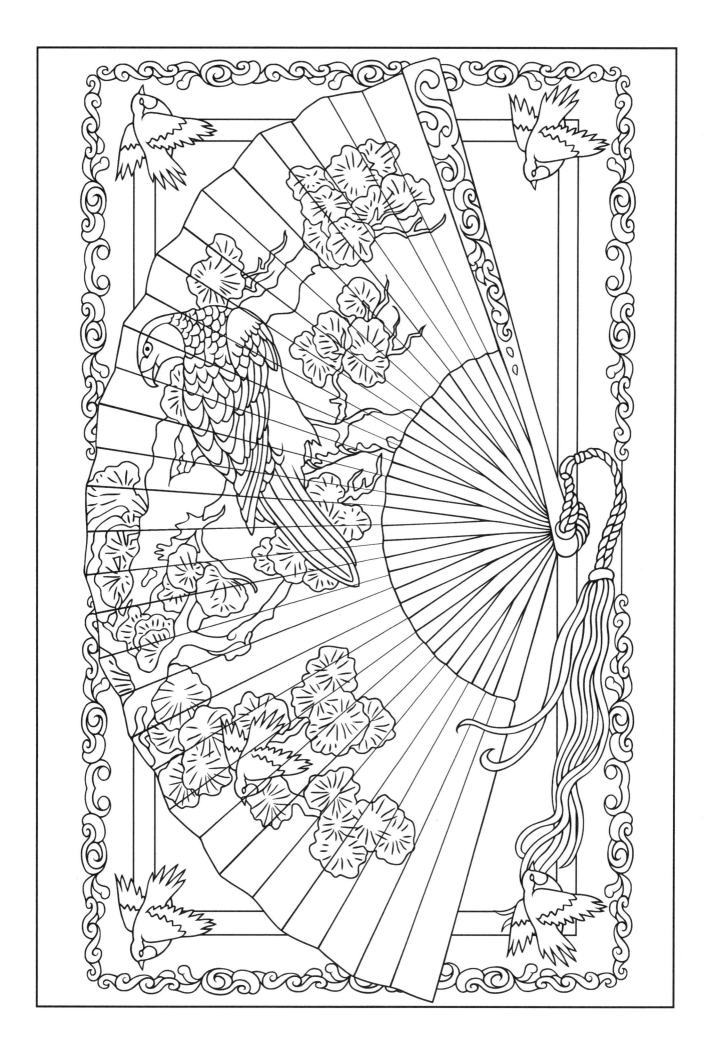

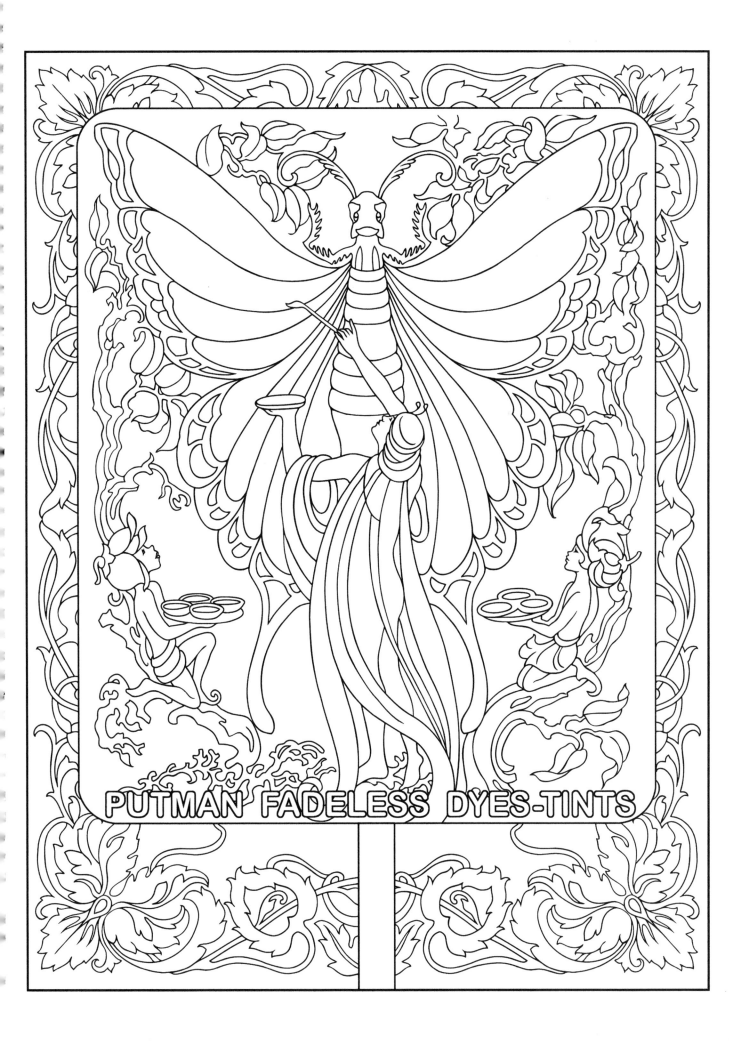

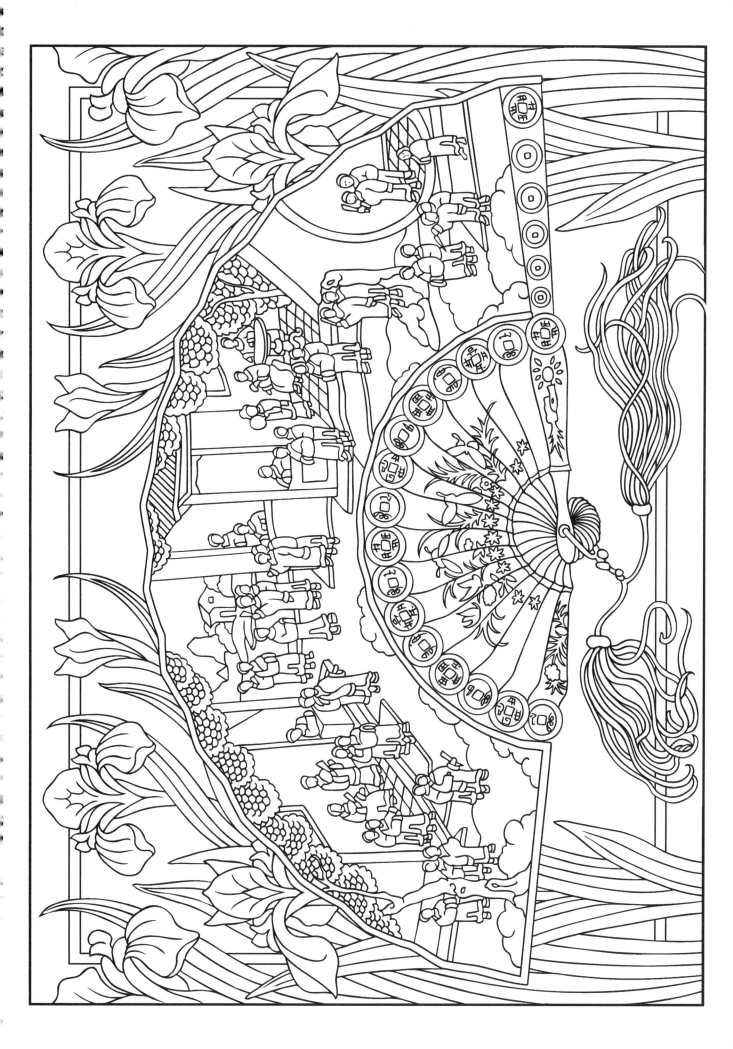

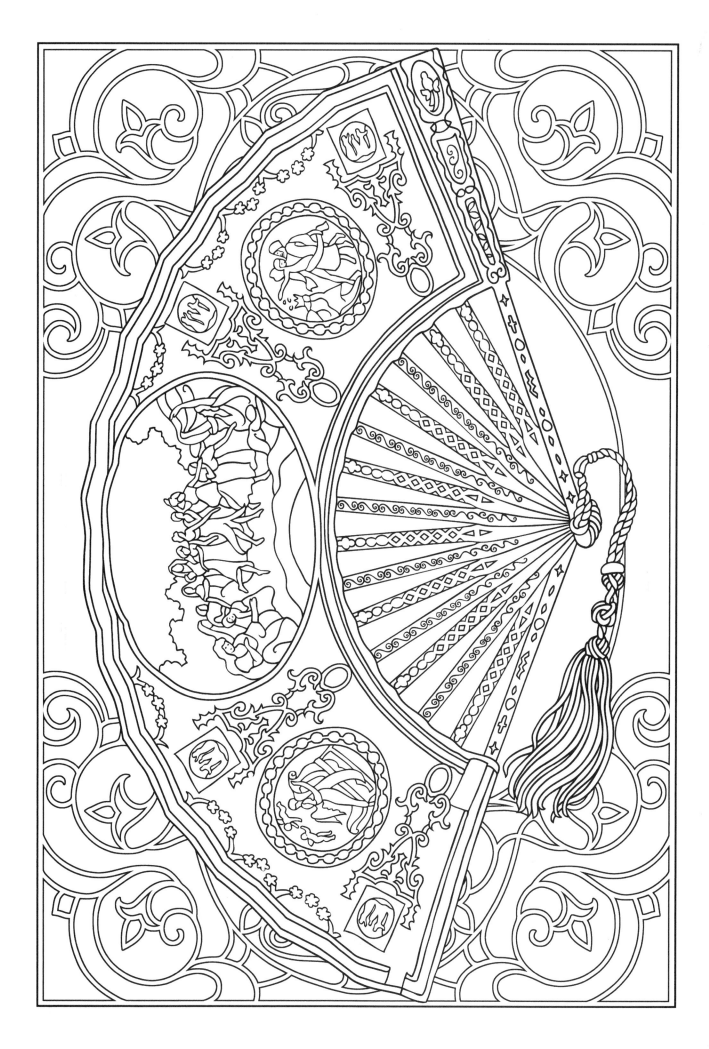

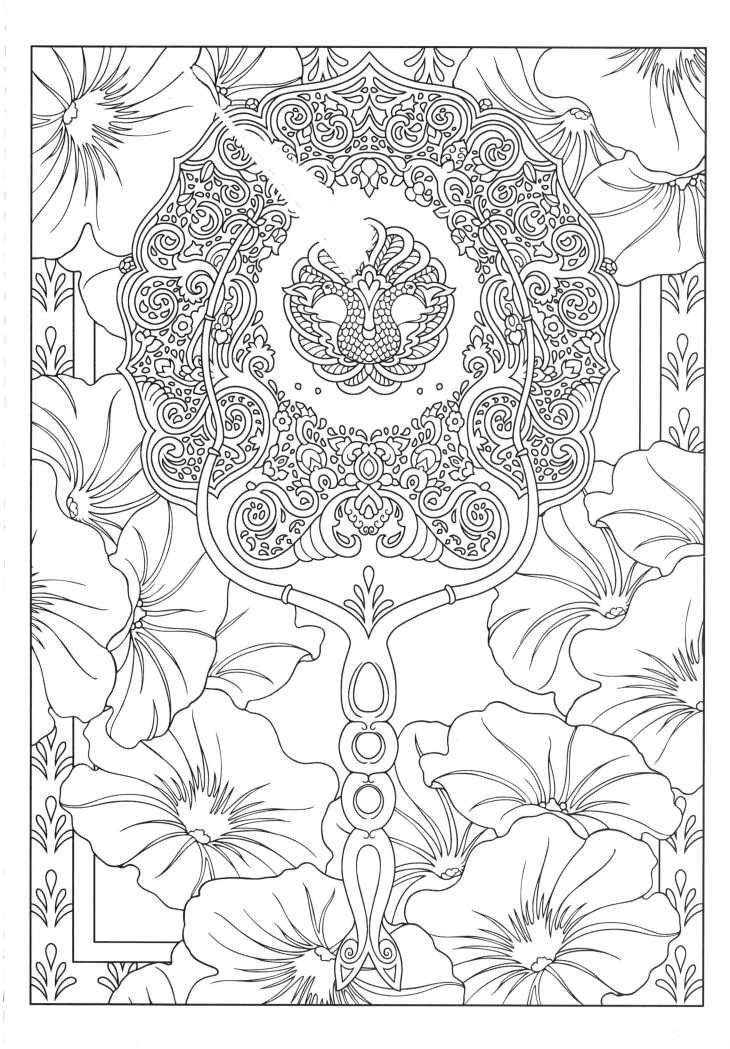

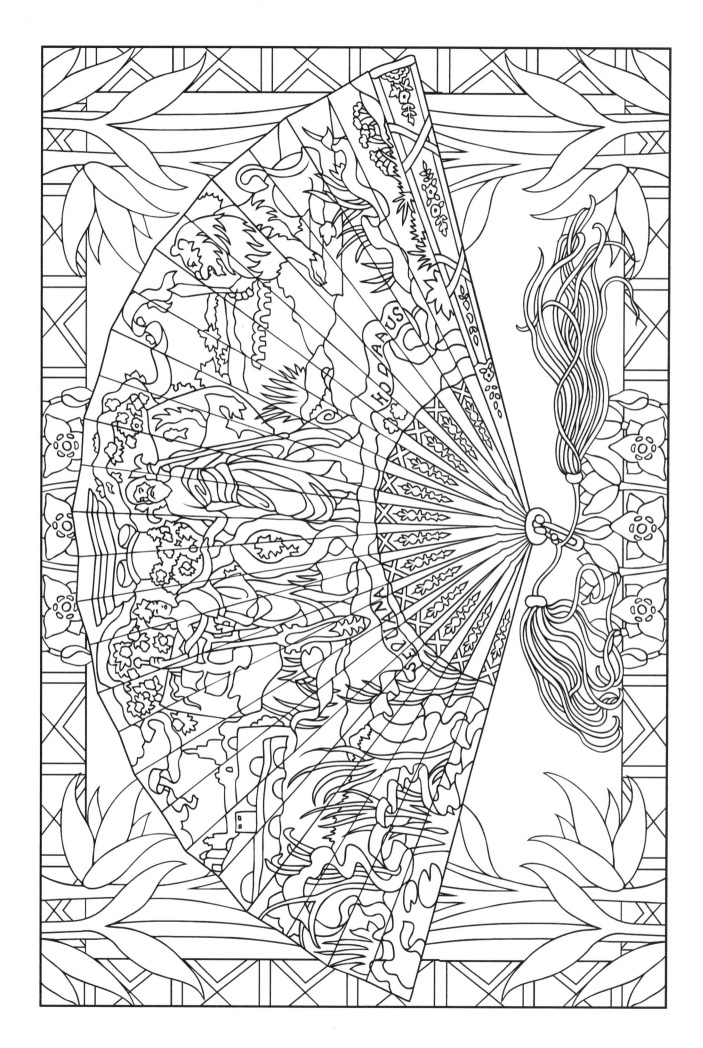

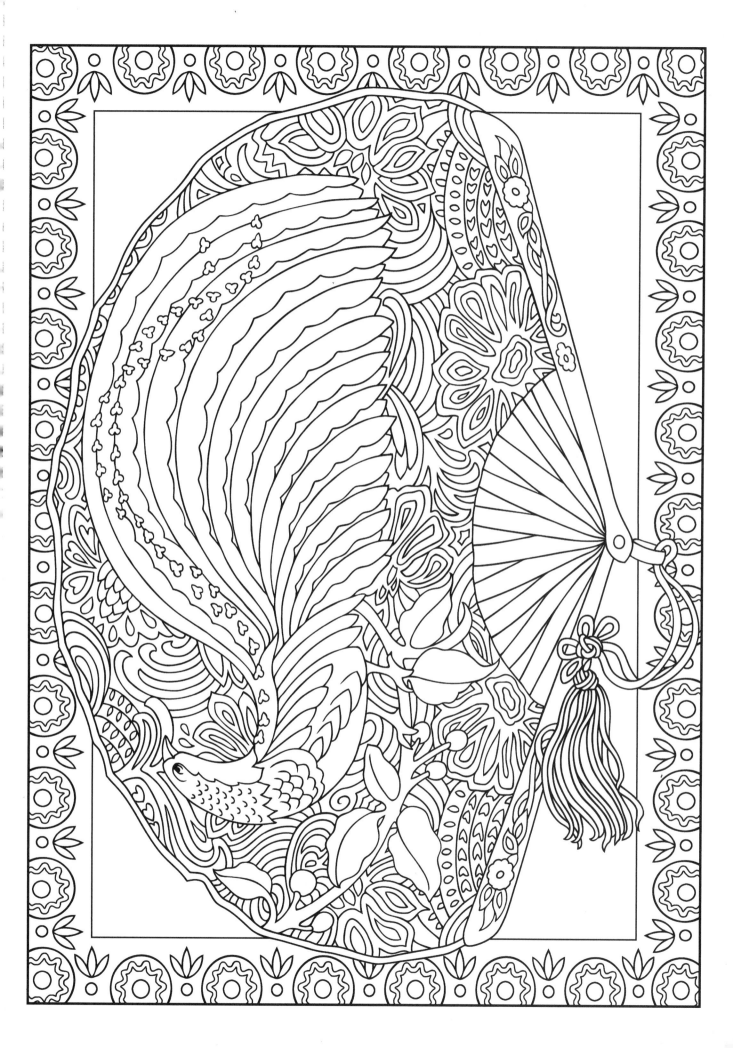

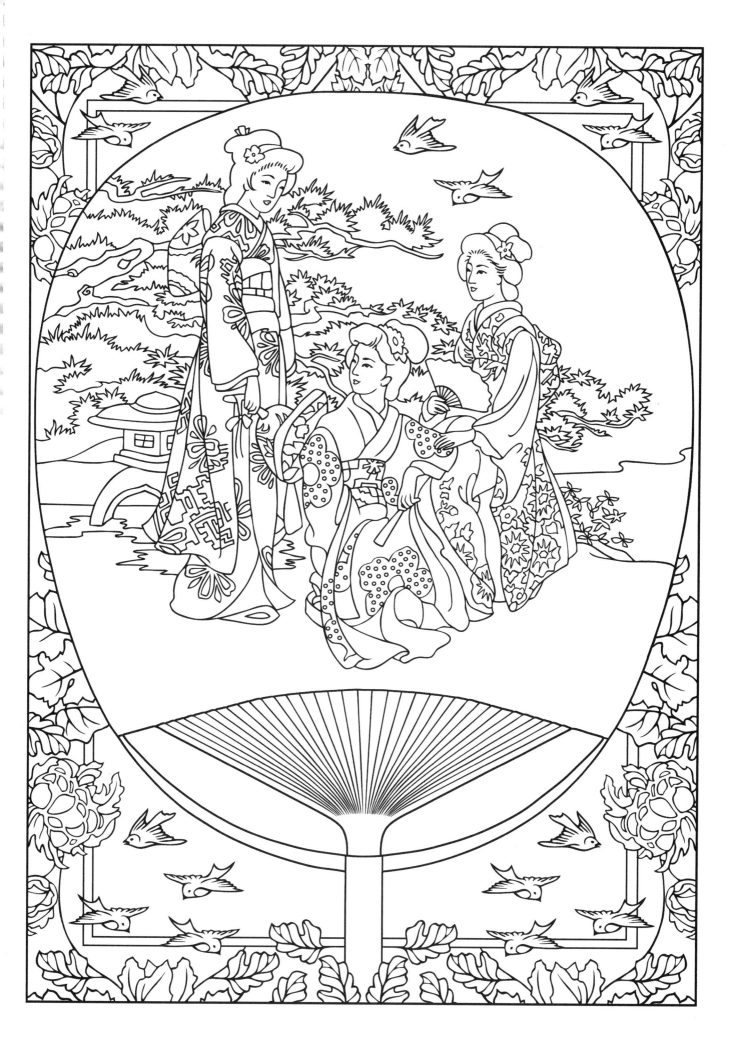

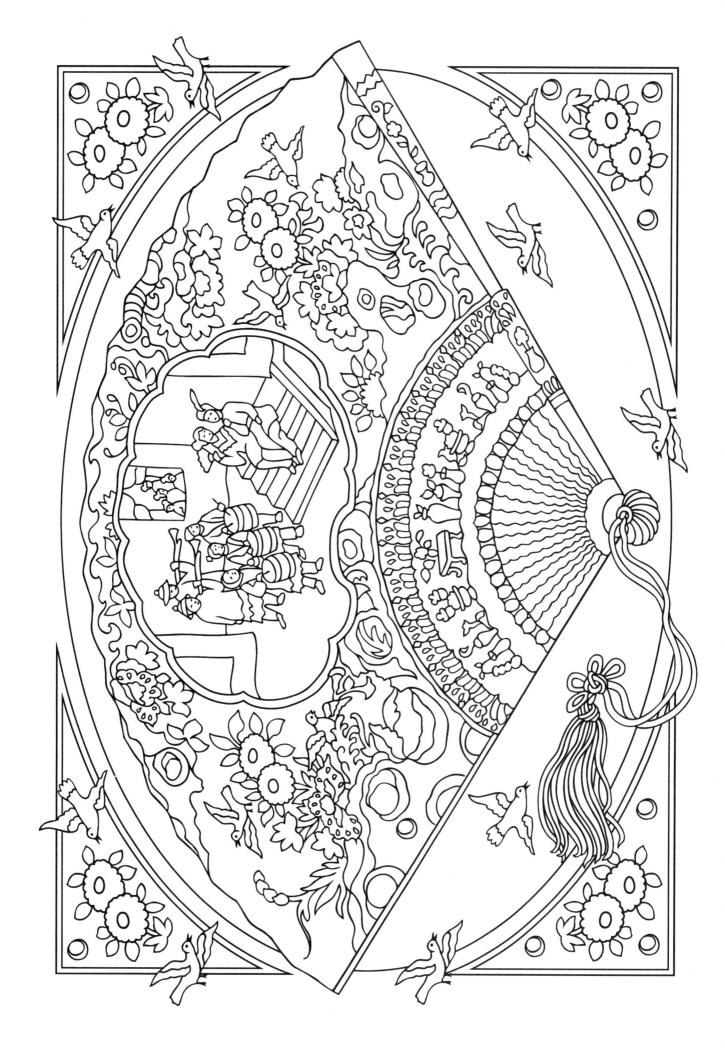